Andy Warhol
Campbell's Soup Cans

STARR FIGURA

THE MUSEUM OF MODERN ART, NEW YORK

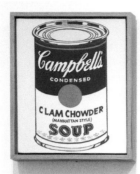
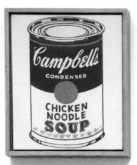
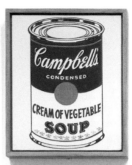
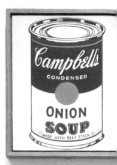
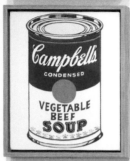
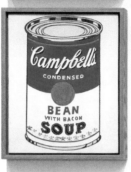
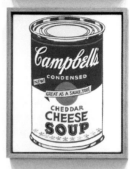

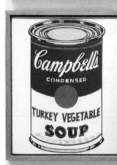
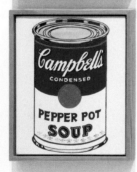
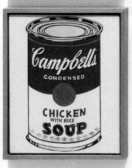
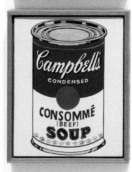

 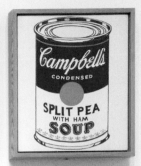

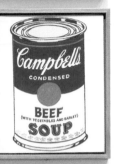 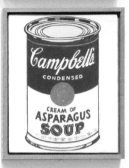 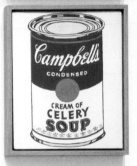 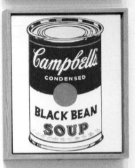

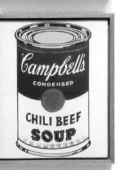 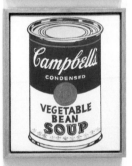 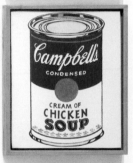

 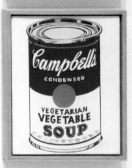

Andy Warhol (American, 1928–1987). *Campbell's Soup Cans*. 1962. Acrylic with metallic enamel paint on canvas, thirty-two panels, each: 20 × 16″ (50.8 × 40.6 cm). THE MUSEUM OF MODERN ART, NEW YORK. PARTIAL GIFT OF IRVING BLUM. ADDITIONAL FUNDING PROVIDED BY NELSON A. ROCKEFELLER BEQUEST, GIFT OF MR. AND MRS. WILLIAM A. M. BURDEN, ABBY ALDRICH ROCKEFELLER FUND, GIFT OF NINA AND GORDON BUNSHAFT, ACQUIRED THROUGH THE LILLIE P. BLISS BEQUEST, PHILIP JOHNSON FUND, FRANCES R. KEECH BEQUEST, GIFT OF MRS. BLISS PARKINSON, AND FLORENCE B. WESLEY BEQUEST (ALL BY EXCHANGE)

ON JUNE 3, 1968, AT 4:51 PM, ANDY WARHOL DIED. SO EXTRAORDINARY WAS HIS artistic run of the past six years, during which he had churned out, as though from an assembly line, one iconic artwork after another—the *Jackies* and *Marilyns*, the Death and Disasters and *Brillo Boxes*—that even had he not been brought back to life minutes later by a team of surgeons at Manhattan's Cabrini Medical Center, he would still be one of the most significant American artists of the past century, and no doubt the most famous.

But in 1962, when he painted his *Campbell's Soup Cans*—the first and ultimately most renowned of his signature series—Warhol was not yet a household name, and Pop art, the movement with which the artist is now identified, was still on the cusp of becoming a phenomenon. Warhol was thirty-three years old, and he had been working for more than a decade as a commercial illustrator in New York. But despite his enviable career in advertising, he had always aspired to be an important painter; he was desperate to make his mark. As the 1950s closed and the '60s dawned, he sensed that a major cultural shift was in the air, and he was determined to embody it. With the *Soup Cans*—thirty-two nearly identical canvases, each one featuring a different variety of Campbell's soup—he hit on a combination of subject (consumer goods), style (simulating the mechanical), and strategy (serial repetition) that he would carry forward as his trademark. The *Soup Cans* were the turning point in Warhol's career, and like their maker they became an icon of the '60s. They mark a pivotal moment in the history of art, and they have profoundly impacted the way artists have approached art-making ever since.

———

Andrew Warhola was born on August 6, 1928, in a Pittsburgh slum, the youngest of three boys. His parents, Andrej and Julia Warhola, working class immigrants from a small Carpatho-Rusyn village that is now part of eastern Slovakia, stressed the value of hard work and strict devotion to the Byzantine Catholic

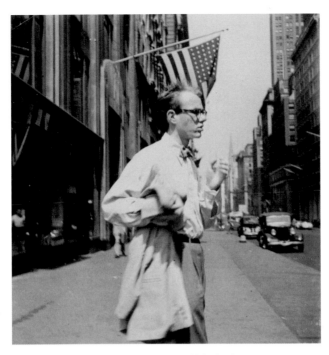

FIG. 1. Andy Warhol, New York, 1949. Photo: Philip Pearlstein

church. Andrej died when Warhol was thirteen. Shy, self-conscious, and slight of build, Andy was a precocious but sometimes sickly and withdrawn child who found comfort in the world of comic books and movie magazines, and in drawing and art. The hardships and poverty of his Depression-era childhood helped to fuel in him a yearning for different circumstances—for money, glamour, and fame. After graduating with a BA in pictorial design from the Carnegie Institute of Technology in 1949—he was the first in his family to go to college—he moved immediately to New York and shortened his name to the less ethnic sounding *Warhol*. His mother, who had nurtured his artistic tendencies, joined him in 1952 and lived with him until the final years before her death in 1972.

In New York, Warhol quickly became a hugely successful commercial artist and fashion illustrator [**FIG. 1**]. Throughout the 1950s and early '60s he created illustrations for *Vogue, Glamour,* and *Harper's Bazaar*; album covers for RCA Records; Christmas cards for Tiffany & Co.; and newspaper ads for the I. Miller shoe company [**FIG. 2**], among many other high-end commissions. Drawing was the basis for much of this advertising work, and his linear style had a witty, eccentric elegance that hovered on the border between naive and sophisticated.

He worked nonstop, and the leading fashion editors adored him for his quirky, rumpled appearance, his stammering shyness, and his unfailing ability to

Don't go away without a **Little Black Silk Shoe!** For all its delicate air, this tireless traveler will grace teas, theatres, restaurants from here to Brussels—from now till '59! I. Miller's tapestry-toed black silk crepe, superbly soft, 31.95. Matched handbag, 17.95*. From a Collection of silks by I. Miller, Evins and Ingenue beginning at 19.95. **I. Miller**

*Plus 10% tax

FIG. 2. Advertisement for I. Miller with drawing by Andy Warhol, *New York Times*, August 4, 1958

produce something fresh and charming and deliver it on time. He was paid top dollar, and his work brought him close to the celebrity world he longed to be a part of, but he was anxious to find his way as a painter, as a "real" artist. He frequented the New York galleries and occasionally bought work by artists he admired, including Jasper Johns, who had recently come to prominence with his paintings of the American flag. Warhol had had some small shows of his noncommercial drawings—mostly portraits of young men [**FIG. 3**]—but Johns and other artists held him at arm's length, leery of his commercial taint and his "swish," as one of Warhol's friends described it.[1]

The monolithic New York art world that Warhol had set his sights on was beginning to splinter. Representing the old guard were the Abstract Expressionists, who continued to dominate the scene as they had since the late 1940s. Jackson Pollock, Willem de Kooning, and others were renowned for their heroically scaled canvases covered in allover drips of paint or sweeping brushstrokes applied with muscularity. The rhetoric of the movement revolved around a sense of moral conviction, alienation, and introspection in the wake of World War II. A lot of masculine swagger and existential angst attended its grand seriousness. Mass culture—"low" Hollywood movies, industrial brands, comic strips, and advertising—was viewed as vulgar, kitschy, and alien to the "high" culture to which these gestural abstractionists were so committed.

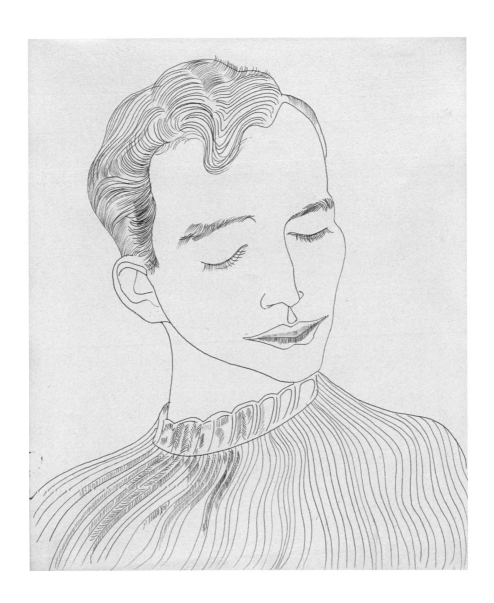

FIG. 3. Andy Warhol (American, 1928–1987). *Untitled (Unknown Male).* c. 1957. Ballpoint pen on paper, 16¾ × 13⅞" (42.5 × 35.3 cm). THE MUSEUM OF MODERN ART, NEW YORK. PURCHASE THROUGH THE VINCENT D'AQUILA AND HARRY SOVIAK BEQUEST FUND

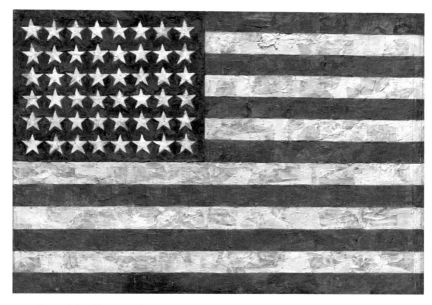

FIG. 4. Jasper Johns (American, born 1930). *Flag.* 1954–55 (dated on reverse 1954). Encaustic, oil, and collage on fabric mounted on plywood, three panels, 42¼ × 60⅝″ (107.3 × 153.8 cm). THE MUSEUM OF MODERN ART, NEW YORK. GIFT OF PHILIP JOHNSON IN HONOR OF ALFRED H. BARR, JR.

The first hint of change appeared when Johns and Robert Rauschenberg arrived on the scene in the mid-1950s. Johns bridged the gap between abstraction and representation by centering his paintings on everyday objects—for example, targets and flags **[FIG. 4]**—that were themselves a kind of abstraction, and Rauschenberg incorporated actual objects, like taxidermic animals and bed linens, into his semi-abstract paintings and assemblages. Their work opened the door for the Pop artists, who emerged around 1960, to start looking out at the world around them rather than away from it and inward.

Within this pregnant atmosphere, Warhol began to make his first paintings. Turning away from the high style of his fashion work, he looked to the more populist, everyman side of consumer culture, to what he called "the harsh, impersonal products and brash materialist objects on which America is built today."[2] He started with comic-strip characters (Batman, Dick Tracy, Popeye) in 1960, but moved away from them when he saw that Roy Lichtenstein was exploring similar subjects **[FIG. 5]**. Warhol was still working as an illustrator and window dresser to pay the bills and, with no galleries yet willing to show these first canvases, he took advantage of an opportunity to put five of them into a Bonwit Teller window display on Fifty-Seventh Street in April 1961 **[FIG. 6]**. They made a surprising, and slightly edgy, backdrop for the colorful shift dresses he'd been assigned to showcase. A subsequent group of paintings took their inspiration

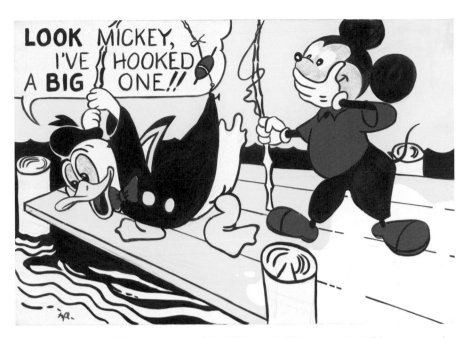

FIG. 5. Roy Lichtenstein (American, 1923–1997). *Look Mickey*. 1961. Oil on canvas, 48 × 69″ (121.9 × 175.3 cm).
THE NATIONAL GALLERY OF ART, WASHINGTON, DC. GIFT OF ROY AND DOROTHY LICHTENSTEIN IN HONOR OF THE
50TH ANNIVERSARY OF THE NATIONAL GALLERY OF ART

from small black-and-white ads for household appliances—televisions, refrigerators, power drills—that he found in the *New York Daily News*. Still bowing to the art world's expectations of painterly brushwork, Warhol incorporated white brushstrokes in the borders of *Water Heater* and let black paint dribble off some of the lettering **[FIG. 7]**. "You can't do a painting without a drip," he remarked at the time.[3]

Warhol's early efforts paralleled those of a host of young artists who were also working with items found in popular culture. No name for it had been settled on, and most of the artists were not yet aware of the others' work, but the first inklings of what would become known as Pop art were in the air, and a number of astute young dealers were eager to discover the next generation of artists and move on from the increasingly exhausted Abstract Expressionist scene.[4] By 1961 Richard Bellamy's Green Gallery had signed Claes Oldenburg, James Rosenquist, and Tom Wesselmann, and Leo Castelli had brought Lichtenstein into his eponymous gallery. The leading New York dealers all visited Warhol in his studio, and some kept a few of his paintings available in their back rooms, but none would give him an exhibition. "All I remember from those years was running around to [the top galleries] and trying to get Andy a show," recalled Henry Geldzahler, a curator of contemporary art at the Metropolitan Museum of Art in New York and one of Warhol's earliest and most steadfast champions, "and everybody saying 'Well, I'm not really sure.'"[5]

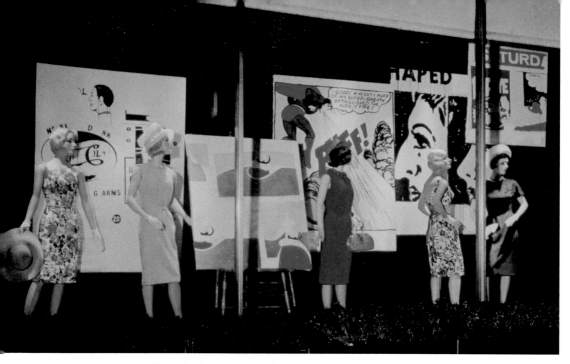

FIG. 6. Window display with paintings by Andy Warhol at Bonwit Teller & Co., Fifth Avenue and East Fifty-Seventh Street, New York, 1961

Warhol's luck began to change when Walter Hopps and Irving Blum, co-owners of the Ferus Gallery in Los Angeles, visited him in his Upper East Side townhouse in the summer of 1961. Ferus was a small space in West Hollywood, founded four years earlier by Hopps, an innovative young curator, and the artist Edward Kienholz, to represent the most daring artists in California. The more business-minded Blum had recently taken over Kienholz's share and was looking to revise the gallery's program to incorporate some of the latest art from New York.

Warhol "buzzed us in," recalled Hopps, "and we climbed the stairs to the first landing, where we found all kinds of strange things and Americana he'd collected in thrift shops and elsewhere—big enamel signs from gas stations, gumball machines, a barber chair, and the pole from outside a barbershop with its red-and-white spiral. Andy met us at the door and ushered us in. He was a quiet guy with an ethereal look, so pale that he looked as if he lived in the dark."[6] (Hopps and Blum were among the first to glimpse the vast collection of art and Americana that Warhol had begun to amass—some might say hoard—from old menus, plane tickets, and cookie jars to master paintings. It took nine days to auction the contents of his home after his death.) In Warhol's large studio, Hopps noted, "the floor was awash with art magazines, fashion magazines, and fanzines, an endless sea of imagery."[7] Warhol's first paintings—the ones based on comic strips and newspaper ads—were set up on easels. Intrigued but still unsure, Hopps and Blum promised to stay in touch.

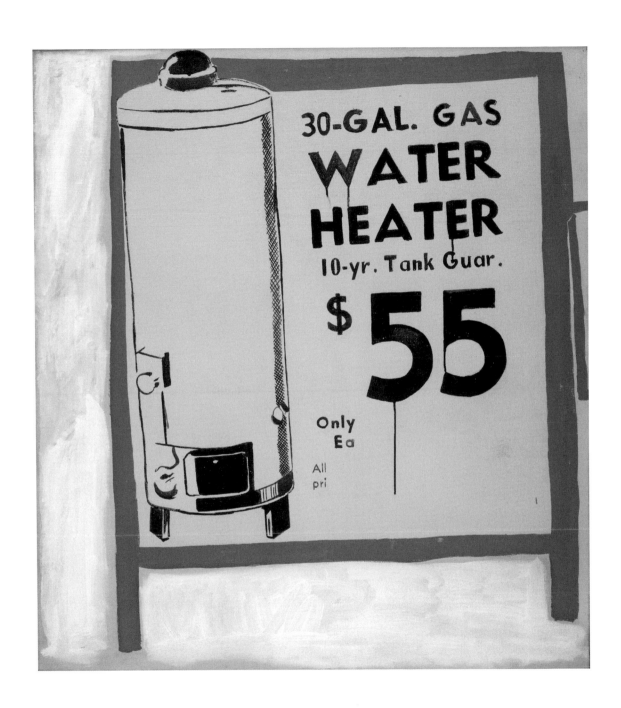

FIG. 7. Andy Warhol (American, 1928–1987). *Water Heater.* 1961. Casein on canvas, 44¾ × 40″ (113.6 × 101.5 cm).
THE MUSEUM OF MODERN ART, NEW YORK. GIFT OF ROY LICHTENSTEIN

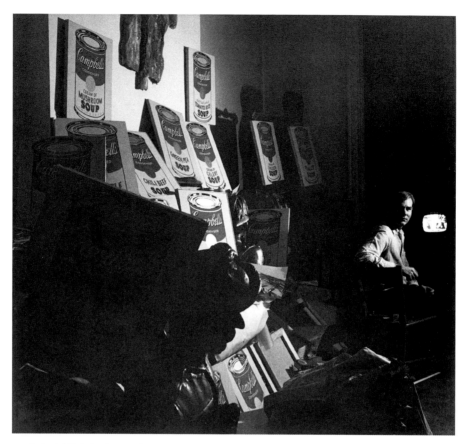

FIG. 8. Andy Warhol at his 1342 Lexington Avenue studio with *Campbell's Soup Cans*, 1962. THE ANDY WARHOL MUSEUM, PITTSBURGH

A few months later, when the two dealers called on the artist again, the first of the *Campbell's Soup Cans* paintings were strewn around the studio [**FIG. 8**]. Warhol explained that it was to be a series of thirty-two—one for every variety of soup the company sold at that time. (To identify all the flavors, the artist referred to a product list supplied by the Campbell Soup Company, checking off each one after completion and adding one new flavor, Turkey Vegetable, not yet represented on the company's list [**FIG. 9**]). "I thought on it for a minute," remembered Blum. "I had a feeling that there was something happening. I bit the bullet."[8] He offered to show the complete series at Ferus. Warhol had never heard of the gallery, but he knew the art scene in Los Angeles was relatively sleepy, and he was hesitant to allow his big debut to take place outside New York. "As he stood thinking," Blum recalled, "I took his arm and said, 'Andy, movie stars come into the gallery'—that sealed the deal."[9]

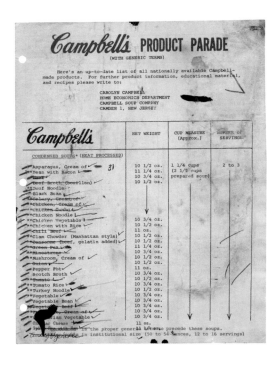

FIG. 9. Product list from the Campbell Soup Company with annotations by Andy Warhol. 1961. THE ANDY WARHOL MUSEUM, PITTSBURGH; FOUNDING COLLECTION, CONTRIBUTION THE ANDY WARHOL FOUNDATION FOR THE VISUAL ARTS, INC.

Warhol got the Campbell's soup idea from a friend, Muriel Latow, a decorator and aspiring art dealer (although there are different accounts of the story).[10] "I've got to do something that will have a lot of impact, that will be different from Lichtenstein and [James] Rosenquist, that will be very personal," he reportedly told her.[11] In exchange for fifty dollars, Latow offered her suggestion: "You should paint something that everybody sees every day, that everybody recognizes . . . like a can of soup."[12] Warhol later advanced the notion that he grew up on Campbell's. "I used to drink it," he said. "I used to have the same lunch every day, for twenty years, I guess, the same thing over and over again."[13] It made for a compelling if possibly apocryphal story, one that Warhol used as part of a broad campaign to burnish his Pop art bona fides.[14]

Campbell's soup appealed to Warhol as a subject not only because of its ubiquity. Ironic icons of American consumer culture, the soup cans nourished the camp aesthetic he slyly cultivated. As one early Warhol critic noted, the artist and his generation grew up in the 1930s, "when the Campbell Soup Kids romped gaily in four colors [in advertisements] in *The Saturday Evening Post*."[15] The company's label design had remained the same for more than fifty years (it would not be substantially updated until 1999), and in 1961 Campbell's ads reminded buyers that the price of a can had not changed in thirty-nine years.[16] Warhol understood instinctively that the old-fashioned brand and its familiar cans could trigger a multiplicity of associations for the American public: wholesome, comforting, and nostalgic on

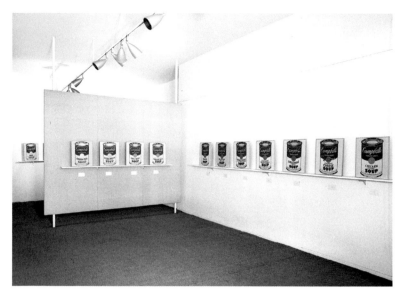

FIG. 10. Installation view with *Campbell's Soup Cans*, Ferus Gallery, Los Angeles, 1962

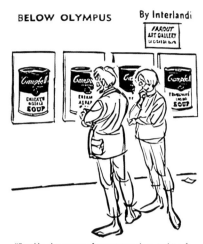

BELOW OLYMPUS By Interlandi

"Frankly, the cream of asparagus does nothing for me, but the terrifying intensity of the chicken noodle gives me a real Zen feeling . . . Besides, asparagus gives me indigestion. . . ! "

FIG. 11. Cartoon by Frank Interlandi about Andy Warhol's solo exhibition at the Ferus Gallery, *Los Angeles Times*, August 1, 1962

the one hand, they were also taken as a campy inside joke among Warhol's gay peers in New York. Warhol had even made a drawing (one of many foot-fetish works he created in the 1950s) depicting a foot pressed up against a Campbell's can on which only the letters C-A-M-P are visible.

The Ferus show opened on July 9, 1962, and closed on August 4 (as it happened, the day Marilyn Monroe died of an overdose in Los Angeles). Warhol was indifferent as to how the paintings would be installed; Blum, knowing it would be difficult to get the identically sized canvases to hang perfectly even, had the idea of putting them on a narrow ledge at eye level around the gallery [FIG. 10]. The suggestion of assembly-line cans on a supermarket shelf was unavoidable—and mildly provocative to an art world bent on maintaining a self-affirming distance between "high" art and "low" culture.

Hopps and Blum "thought that the show would be a sensation, but it was ridiculed in the press."[17] Warhol's flattened aesthetic and deadpan attitude were lost on an art world conditioned to expect that paintings should reverberate with virtuoso brushwork and existential feeling [FIG. 11]. "Warhol obviously doesn't want to give us much to cling to in the way of sweet handling, preferring instead the hard commercial surface of his philosophical cronies. But then house fetishes rarely compete with Rembrandt," wrote Henry T. Hopkins in *Artforum*.[18] Another gallery up the street from Ferus even put a mocking display of actual Campbell's

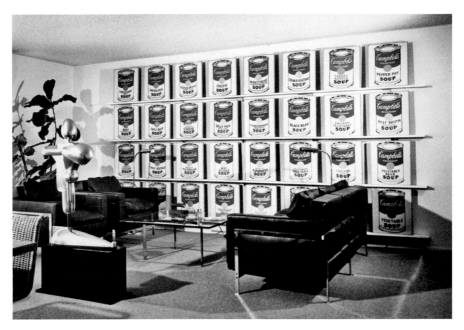

FIG. 12. *Campbell's Soup Cans* installed in Irving Blum's apartment, Los Angeles, 1968. FRANK J. THOMAS ARCHIVES

soup cans in its window, piled up in a pyramid as if in a grocery store. A sign read: "Do Not Be Misled. Get the Original. Our Low Price—Two for 33 Cents."[19]

Only six of the paintings sold, for a price of $100 each. Among the Hollywood buyers were actor Dennis Hopper, one of the first to embrace and collect Pop art, and Don Factor, the son of cosmetics magnate Max Factor. Blum realized it might be more advantageous to keep the paintings together, and he managed to cancel the sales and negotiate with Warhol to buy the complete set for $1,000, which he paid in $100 installments for ten months. Warhol hadn't necessarily intended for the canvases to stay together, but this twist of fate preserved serial repetition as a key part of their impact and legacy.

Blum kept the *Soup Cans* in his apartment for nearly thirty-five years, lending them occasionally to important exhibitions [**FIG. 12**]. In 1996 The Museum of Modern Art acquired them from him. The price, as eagerly reported in the press, was $15 million—among the highest ever paid at that point for a contemporary work of art and a sign of the iconic status the *Soup Cans* had come to occupy in art history.[20] Kirk Varnedoe, who negotiated the acquisition as MoMA's chief curator of painting and sculpture, called the series one of the "major, defining masterpieces of American art of the 1960s."[21]

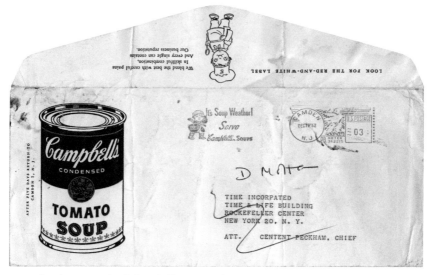

FIG. 13. Envelope printed with Campbell's soup graphic, 1962. COLLECTION THE ANDY WARHOL MUSEUM, PITTSBURGH; FOUNDING COLLECTION, CONTRIBUTION THE ANDY WARHOL FOUNDATION FOR THE VISUAL ARTS, INC.

The *Campbell's Soup Cans* marked the onset of a remarkably productive and auspicious year for Warhol. Among the extraordinary series he developed over the rest of 1962 and into 1963 were the paintings known as the *Marilyns,* the *Elvises,* and the Death and Disasters. In them Warhol continued to pursue the strategy of serial repetition, whether through the creation of multiple canvases as variations on the same theme or as a single canvas gridded with repeated images. In making these and other paintings that year he struck on a new medium, silkscreen (also known as screenprint), that amplified the mechanical implications of his art. It immediately became his signature technique.

Warhol had made the thirty-two panels of *Campbell's Soup Cans* painstakingly by hand, using a projector to enlarge the logo that appeared on the Campbell Soup Company's envelopes [**FIG. 13**] and then tracing it. With the pencil lines as his guide, he filled in the outlined shapes with acrylic paint (a medium then associated with commercial work, as opposed to the "fine" art of oil painting) and used a rubber stamp to apply the rows of gold fleurs-de-lis at the bottom of each can. Though there are a few subtle discrepancies in the red and white tones and the gold stamps and medallions, Warhol was careful to maintain an exceptional uniformity among the canvases and to minimize the visibility of brushstrokes or other signs of his own hand.

Having laboriously handcrafted those thirty-two nearly identical works, he wanted to find a more efficient method for replicating images. He tried using stencils as an aid in a few *Soup Can* paintings he made shortly thereafter, including *200 Campbell's Soup Cans,* a single canvas in which he consolidated the principle of repetition into a large grid [**FIG. 14**]. He also tried rubber stamping an entire canvas,

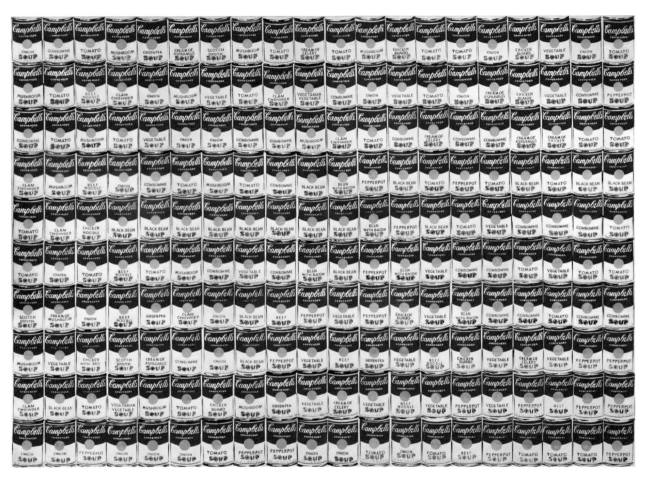

FIG. 14. Andy Warhol (American, 1928–1987). *200 Campbell's Soup Cans.* 1962. Casein, spray paint, and pencil on cotton, 6′ × 8′ 4⅛″. (182.9 × 254.3 cm). PRIVATE COLLECTION

FIG. 15. Andy Warhol (American, 1928–1987). *S&H Green Stamps.* 1962. Silkscreen ink on synthetic polymer paint on canvas, 71¾ × 53¾″ (182.3 × 136.6 cm). THE MUSEUM OF MODERN ART, NEW YORK. GIFT OF PHILIP JOHNSON

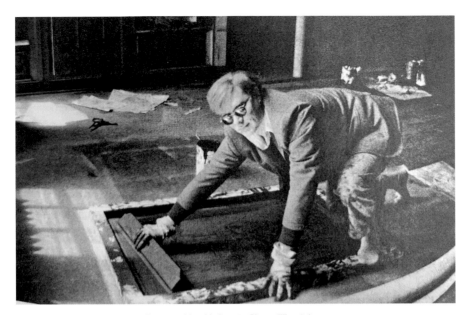

FIG. 16. Andy Warhol pulling a silkscreen, New York, 1963. Photo: Ellen Johnson

which allowed for small motifs to be repeated endlessly [**FIG. 15**]. But this was still very labor-intensive and felt, as he later remarked, "homemade."[22]

Silkscreening, a commercial technique for printing wallpaper and fabric, was faster and freer, more mechanical and impersonal than any of those other methods of applying paint. Warhol would have been familiar with its applications in fashion and advertising, and he had also been exposed to it as an art medium in the 1940s, when he saw an exhibition of WPA artists who used it, exceptionally, to make prints. The aesthetic of silkscreen is industrial—flat, colorful, and hard-edged—but it is malleable enough to allow for variable colors and subtle shifts in registration from one copy to the next. It enabled Warhol to finally achieve what he called "an assembly-line effect" [**FIG. 16**].[23]

Silkscreen also allowed Warhol to incorporate photographic imagery into his work and make celebrities a new focus. His images of movie stars—Troy Donahue, Elizabeth Taylor, and others, in addition to Marilyn Monroe [**FIG. 17**] and Elvis Presley [**FIG. 18**]—were typically based on publicity stills from the film industry. "With silkscreening," Warhol explained, "you pick a photograph, blow it up, transfer it in glue onto silk, and then roll ink across it so the ink goes through the silk but not through the glue. That way you get the same image, slightly different each time. It was all so simple—quick and chancy. I was thrilled with it."[24]

The numerous paintings of Monroe that Warhol silkscreened in 1962–63 and the editioned portfolio of ten screenprints, *Marilyn Monroe,* that he made in 1967 [**FIG. 19**] were all based on the same promotional still for the movie *Niagara* (1953),

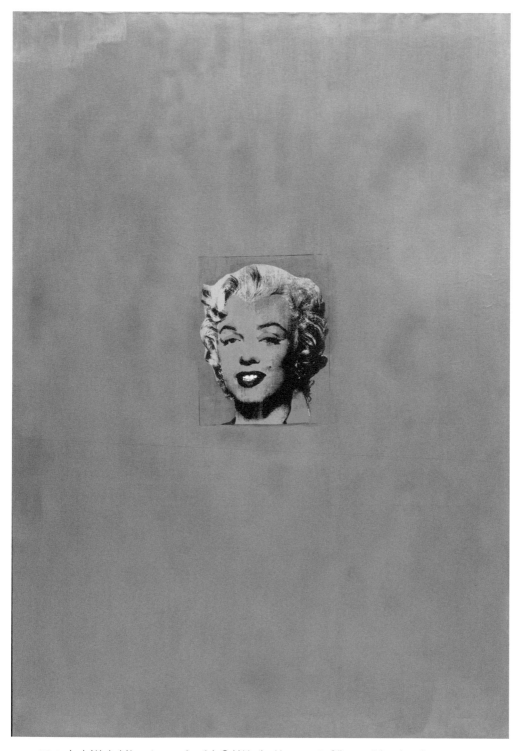

FIG. 17. Andy Warhol (American, 1928–1987). *Gold Marilyn Monroe.* 1962. Silkscreen ink and acrylic on canvas, 6′ 11¼″ × 57″ (211.4 × 144.7 cm). THE MUSEUM OF MODERN ART, NEW YORK. GIFT OF PHILIP JOHNSON

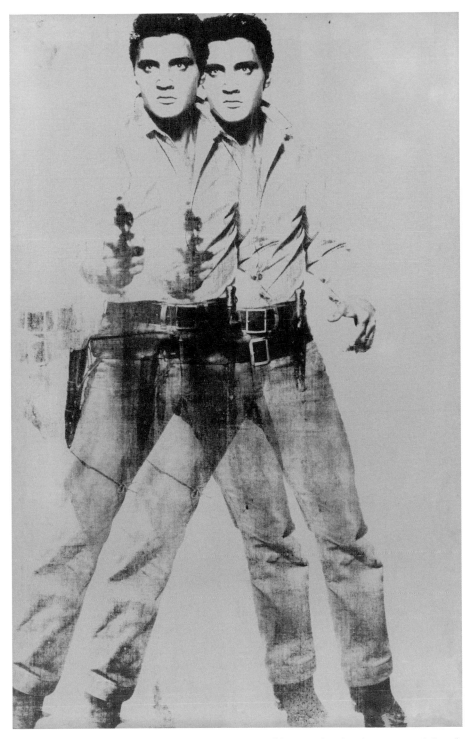

FIG. 18. Andy Warhol (American, 1928–1987). *Double Elvis.* 1963. Silkscreen ink and acrylic on canvas, 6′ 11″ × 53″ (210.8 × 134.6 cm). THE MUSEUM OF MODERN ART, NEW YORK. GIFT OF THE JERRY AND EMILY SPIEGEL FAMILY FOUNDATION IN HONOR OF KIRK VARNEDOE

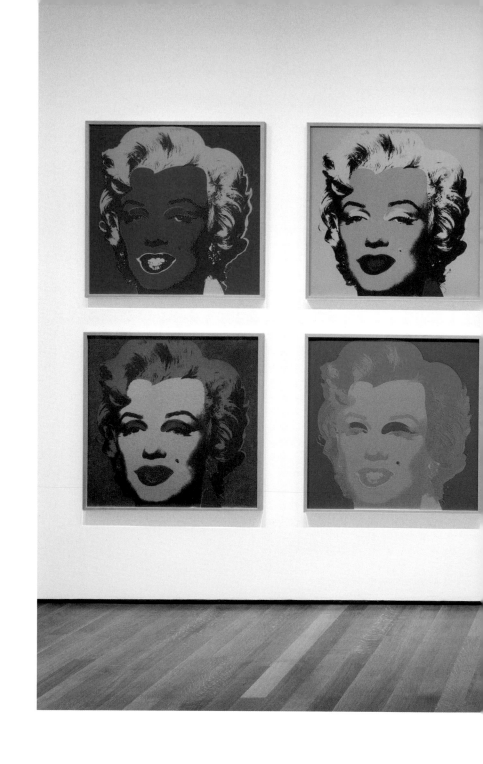

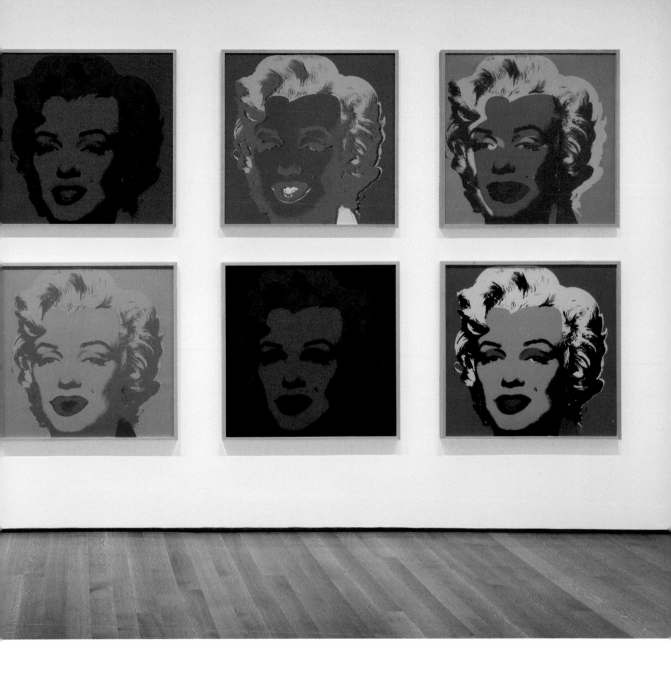

FIG. 19. Andy Warhol (American, 1928–1987). *Marilyn Monroe.* 1967. Portfolio of ten screenprints, each: 36 × 36″ (91.5 × 91.5 cm). Publisher: Factory Additions, New York. Printer: Aetna Silkscreen Products, Inc., New York. Edition: 250. THE MUSEUM OF MODERN ART, NEW YORK. GIFT OF MR. DAVID WHITNEY

FIG. 20. Publicity still for the film *Niagara* (1953), source mechanical for the Marilyn series, with crop marks by Andy Warhol. Photo: Gene Korman. THE ANDY WARHOL MUSEUM, PITTSBURGH; FOUNDING COLLECTION, CONTRIBUTION THE ANDY WARHOL FOUNDATION FOR THE VISUAL ARTS, INC.

which he sometimes cropped to a rectangular bust, sometimes to a more tightly framed square face [**FIG. 20**]. Warhol's *Marilyn*s are depicted in a similar manner to his *Campbell's Soup Cans*: free-floating, without any background details or context. Indeed, when Walter Hopps asked the artist how he would describe the *Campbell's Soup Cans,* Warhol gave him a funny smile and said, "I think they're portraits, don't you?"[25] In both series, Warhol effected a quasi-religious, profoundly ironic transfiguration of a consumer product—a can of industrially manufactured soup, a movie star fabricated by the Hollywood publicity machine—to the elevated status of a holy relic or a devotional image. While the *Marilyn*s might seem at first to be more obviously so, the central gold medallions in the Campbell's labels, repeated thirty-two times, echo the series of identical halos that Warhol would have seen every Sunday as a boy encircling the heads of the saints on the iconostasis (or screen of icon paintings) at St. John Chrysostom Byzantine Catholic Church on Saline Street in Pittsburgh. When we call the *Soup Cans* iconic, we are to some degree being literal.

Painters had long used photographs as a tool, but they typically concealed that fact because it was considered a kind of cheat. With a one-two punch, Warhol brought mass-media photography and commercially purposed silkscreen into "serious" painting. By using techniques of mechanical reproduction (the very techniques through which commercial products were being disseminated and popularized) to depict consumer-oriented subjects, he achieved a provocative marriage of form and content. Affirming his commitment to repetition over uniqueness, populism over elitism, he explained that "mechanical means are *today,* and using them I can get more art to more people. Art should be for everyone."[26] And in the ultimate rebuke to the Abstract Expressionists' cult of individual,

soul-searching self-expression he declared, "The reason I'm painting this way is that I want to be a machine."[27]

Warhol's breakthroughs were key developments within the larger phenomenon of Pop art as it burst onto the American scene in a slew of exhibitions and magazine articles in 1962. In May, *Time* published the first mass-circulation essay on the new movement, titled "The Slice-of-Cake School." Warhol was profiled along with Lichtenstein, Rosenquist, and Wayne Thiebaud (a painter known for his lusciously brushed paintings of cakes), and the magazine pictured the young artist eating from a can of Campbell's soup. In the fall the first major group exhibitions featuring the emerging Pop artists, including Warhol, took place: *New Painting of Common Objects* was organized by Hopps at the Pasadena Art Museum, and *The New Realists* opened at the venerable Sidney Janis Gallery in New York.

In November 1962 Warhol's second solo show of the year took place at the Stable Gallery, a leading New York tastemaker. In contrast to the quiet scene at the Ferus Gallery, the Stable opening was a major cultural event and represented Warhol's long-sought coronation within the New York art world. The show sold out, and within a month its centerpiece, *Gold Marilyn Monroe* [see **FIG. 17**], had entered the collection of The Museum of Modern Art.

It is unclear if any *Soup Can* paintings were included in the Stable show (more than half of its seventeen works were variously colored *Marilyns*).[28] But by that point Campbell's soup was effectively Warhol's calling card; he distributed a "Green Pea Soup" button to everyone who attended the opening. The critics and the public had seized on Pop art as a controversial new movement—was it legitimate, or was it a put-on?—and Warhol and his *Soup Cans* were its emblems. At the same moment the Stable exhibition was opening, the critic John Coplans published a review of the Pasadena show in which he referred to Warhol's soup cans as "now famous."[29]

So compelling—and threatening—was the arrival of Pop that The Museum of Modern Art convened a public symposium to debate the new movement in December of 1962 (within a week of its *Gold Marilyn* acquisition). The panelists, including art historians Dore Ashton and Leo Steinberg, critic Hilton Kramer, poet and critic Stanley Kunitz, Henry Geldzahler of the Met, and curator Peter Selz of MoMA, were mostly apologists for the Abstract Expressionists. Geldzahler, the youngest of the panelists at age twenty-seven, was the only unequivocal Pop enthusiast. Most of the discussants expressed skepticism toward Pop's commercial subject matter and its mechanical (or mechanical-looking) techniques. Both were seen as an affront to ingrained notions of what qualified as art. Kunitz, for example, argued that it was difficult to consider Warhol's "celebrated rows of Campbell's Soup labels" as paintings at all "since, apparently, the serial image has been mechanically reproduced with the aid of a stencil."[30]

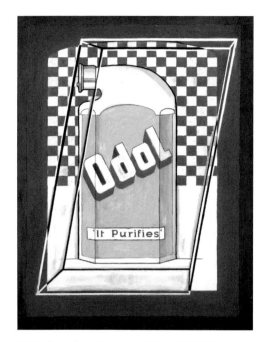

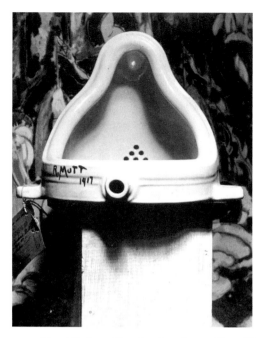

FIG. 21. Stuart Davis (American, 1892–1964). *Odol.* 1924. Oil on cardboard, 24 × 18″ (60.9 × 45.6 cm). THE MUSEUM OF MODERN ART, NEW YORK. MARY SISLER BEQUEST (BY EXCHANGE) AND PURCHASE

FIG. 22. Marcel Duchamp (American, born France. 1887–1968). *Fountain.* 1917. Porcelain, dimensions unknown. Photo: Alfred Stieglitz

Despite the protests of certain critics, Warhol's real-world emphasis and unorthodox techniques were not without precedent in the history of modern art. Stuart Davis, an artist Warhol had admired since his student days, was one of several American painters working in the 1920s and '30s who combined American subject matter with the abstracting language of European modernism. Davis's *Odol* (1924; **FIG. 21**), for example, is a hard-edged, geometrized depiction of a trademarked mouthwash that anticipates Warhol's *Soup Cans*. Through Davis, a lineage for the *Soup Cans* can be traced back to the Cubists, especially Picasso and Braque, who began pasting newspaper clippings onto their canvases in 1912, and to Marcel Duchamp, a pioneer of Dada, who invented his "readymades"—found objects such as a bottle rack, a snow shovel, and a urinal **[FIG. 22]** that he selected and presented as art—in 1913. As these examples demonstrate, avant-garde artists had often sought to bring everyday life into their art and, at times, to do so through the radical introduction of non-art methods and materials.

Duchamp in particular was a touchstone for Warhol—whose life-size, silk-screened-plywood replicas of Brillo boxes **[FIG. 23]** are obvious descendants of the readymade—and for many Pop and proto-Pop artists (such as Johns and Rauschenberg).[31] And "Neo-Dada" was one of several terms used to describe the new movement before "Pop art" lodged itself in the public consciousness. (Others

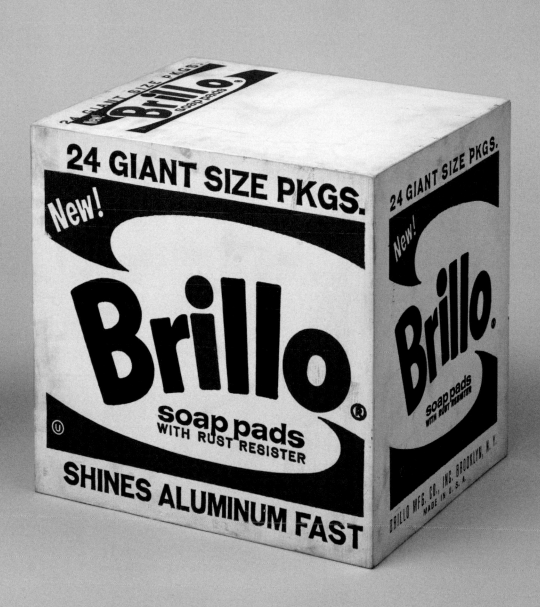

FIG. 23. Andy Warhol (American, 1928–1987). *Brillo Box (Soap Pads)*. 1964. Polyvinyl acetate paint and silkscreen ink on wood, 17⅛ × 17 × 14″ (43.3 × 43.2 × 36.5 cm). THE MUSEUM OF MODERN ART, NEW YORK. GIFT OF DORIS AND DONALD FISHER

included "Commonism," "New Realism," and "OK Art.") An elder statesman in the 1960s, Duchamp was in fact one of the first to recognize the conceptual gambit of Warhol's repetitions. As he noted, "If you take a Campbell's Soup can and repeat it fifty times, you are not interested in the retinal image. What interests you is the concept that wants to put fifty Campbell's Soup cans on a canvas."[32]

Pop art was a response to real changes in American life after World War II, changes that became most pronounced in the 1960s. New technologies for mass production and advancements in distribution and mass communications touched every facet of society. The visual landscape was dramatically transformed as national chains proliferated along the country's expanding highways, and brand-name merchandise flooded enormous new supermarkets. Increasingly sophisticated, nationwide advertising campaigns blanketed the growing mediascape, from mass-circulation publications to television and other advanced broadcasting systems. In the decade after 1947 the number of television sets in American homes jumped from ten thousand to forty million,[33] and, according to *Time*, by 1962 the average American was exposed to approximately sixteen hundred ads per day.[34]

Like Warhol, most of the Pop artists had grown up in middle or working-class families. They came of age during the 1950s, when America's burgeoning commodity culture was internationally recognized as a sign of the country's economic and political dominance. Foodstuffs appear especially frequently in Pop art, and the items the Pop artists selected—from Warhol's soup cans and Oldenburg's cheeseburgers **[FIG. 24]** to Thiebaud's meringue pies and Wesselmann's supermarket-brand still lifes **[FIG. 25]**—typically had a resonance that was at once

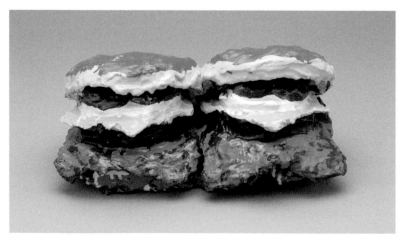

FIG. 24. Claes Oldenburg (American, born Sweden. 1929). *Two Cheeseburgers, with Everything (Dual Hamburgers)*. 1962. Burlap soaked in plaster, painted with enamel, 7 × 14¾ × 8⅝" (17.8 × 37.5 × 21.8 cm). THE MUSEUM OF MODERN ART, NEW YORK. PHILIP JOHNSON FUND

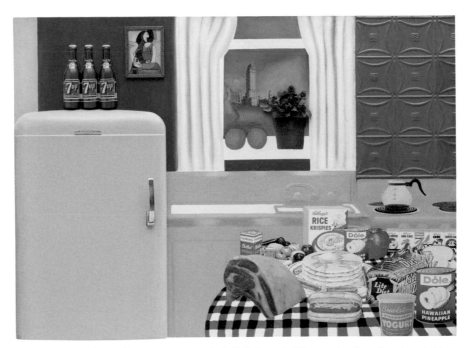

FIG. 25. Tom Wesselmann (American, 1931–2004). *Still Life #30.* 1963. Oil, enamel, and acrylic on board with collage of printed advertisements, plastic flowers, refrigerator door, plastic replicas of 7-Up bottles, glazed and framed color reproduction, and stamped metal, 48½ × 66 × 4″ (122 × 167.5 × 10 cm). THE MUSEUM OF MODERN ART, NEW YORK. GIFT OF PHILIP JOHNSON

nostalgic, aspirational, and ironic. In broad terms they signified the rapid expansion of the middle-American "good life" after World War II. "What's great about this country," Warhol observed, "is that America started the tradition where the richest consumers buy essentially the same things as the poorest. You can be watching TV and see Coca-Cola, and you can know that the President drinks Coke, Liz Taylor drinks Coke, and just think, you can drink Coke, too. A Coke is a Coke and no amount of money can get you a better Coke than the one the bum on the corner is drinking. All the Cokes are the same and all the Cokes are good."[35]

But the so-called American Dream was not without its dark side. Warhol's one-after-another *Soup Cans* speak of excess as much as abundance, of conformity as much as comfort. The rows upon rows of red-and-white labeling can seem jumpy and loud one minute, flat and monotonous the next. His *Marilyns*, begun in response to Monroe's suicide in 1962, emerged out of a lifelong preoccupation with death; their shimmering repetitions seem at first to address the ubiquitous glamour of her image, but with each ghoulishly off-register variation, their subtle irony gives way to deep disquiet. In Warhol's Death and Disaster series, based on newspaper images of car accidents, electric chairs, and other gruesome vehicles of death in America **[FIG. 26]**, the artist's strategy of repetition

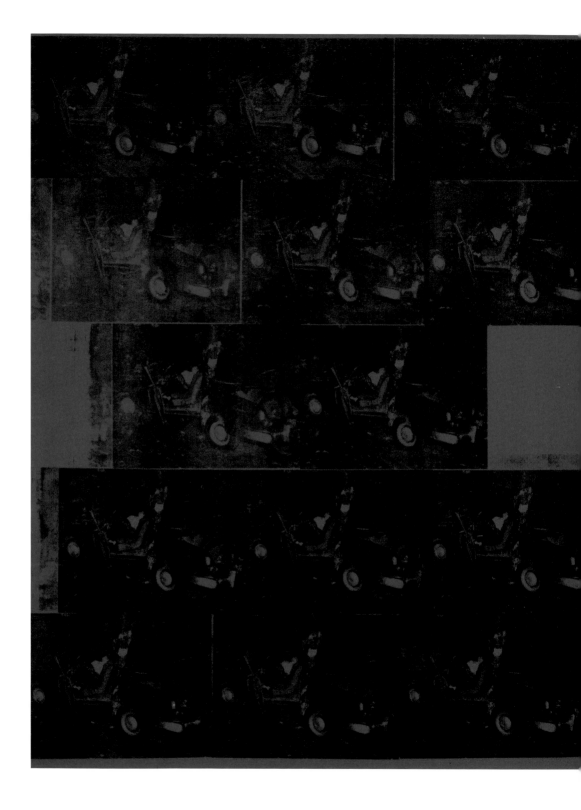

FIG. 26. Andy Warhol (American, 1928–1987). *Orange Car Crash Fourteen Times*. 1963. Silkscreen ink on acrylic paint on two canvases, 8′ 9 ⅞″ × 13′ 8 ⅛″ (268.9 × 416.9 cm). THE MUSEUM OF MODERN ART, NEW YORK. GIFT OF PHILIP JOHNSON

is connected even more disturbingly to the way mass-media overload tends to diffuse the traumatic impact of a given image. As Warhol remarked flatly, with characteristic irony, "The more you look at the same exact thing, the more the meaning goes away, and the better and emptier you feel."[36]

Scholars have debated whether Warhol's choices and strategies were impassive and indiscriminate or an expression of real conceptual engagement and sublimated feeling. Warhol's own statements were deliberately opaque and contradictory, and he actively discouraged any suggestion of deeper meaning in his work. "If you want to know all about Andy Warhol," he advised, "just look at the surface: of my paintings and films and me, and there I am. There's nothing behind it."[37] He liked to give the impression that he hit on his subjects by luck, without knowing why he selected them or what they meant. In his interviews and published diaries he affected a deadpan blankness, but those who knew him insisted it was an act. "Warhol only plays dumb," said Geldzahler. "It's his style. . . . He's incredibly analytical, intellectual, and perceptive."[38] He had an eye for the images and objects that speak of American culture at its most elemental, and he knew that when presented as works of art they could provoke a range of projections on the part of the viewer. (As if to underscore this operation in his work, he created a series of large *Rorschach* paintings in the 1980s, modeled on the famous "inkblot" test invented by the Swiss psychiatrist Hermann Rorschach [FIG. 27]. Ironically, they are among the few works in which Warhol did not rely on preexisting images; he made each one by painting an abstraction on one side of a canvas and then folding it in half vertically to imprint the other side.)

Celebratory or critical, straightforward or subversive, engaged or indifferent—dualism is at the heart of Warhol's art, beginning, most crucially, with the *Campbell's Soup Cans*. "He was like no artist I had ever met," remarked the artist Edward Ruscha, who met Warhol in 1963, "because he was for everything and nothing at the same time."[39]

———

As the 1960s progressed, Warhol continued to mine American commodity culture for the subjects of his paintings and sculptures, and as he became famous he took it upon himself to fulfill the public's expectations of what a Pop artist might be. He replaced his chino pants and oxford shirts with a counterculture uniform of leather jacket, Ray-Ban sunglasses, and platinum wig (worn, in part, to camouflage his baldness) [FIG. 28]. He cultivated an aura of detached, offbeat glamour and pursued a career and lifestyle that merged high art, underground culture, and commercial enterprise. In 1963 he moved his studio to East Forty-Seventh Street, where it was dubbed the Factory, and he hired a crew of assistants to help him produce his art, assembly-line style. (The Factory would eventually move to two other locations.) Wallpapered in aluminum foil, it was

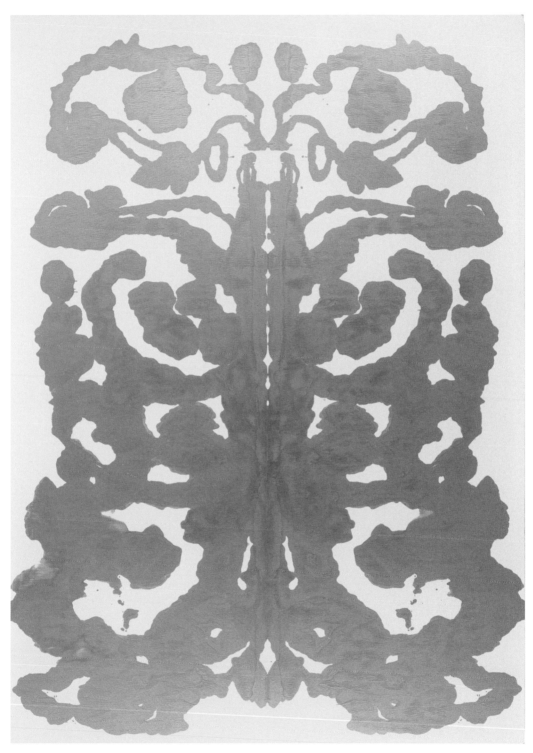

FIG. 27. Andy Warhol (American, 1928–1987). *Rorschach*. 1984. Synthetic polymer paint on canvas, 13′ 8¼″ × 9′ 7″ (417.2 × 292.1 cm). THE MUSEUM OF MODERN ART, NEW YORK. PURCHASE

FIG. 28. Stephen Shore (American, born 1947). *Andy Warhol, Sam Green, Marcel Duchamp, Cordier Ekstrom Gallery, New York.* 1965–67; printed c. 2007. Gelatin silver print, 12¾ × 19″ (32.4 × 48.3 cm)

notorious as a gathering place for a Pop-embracing cross-section of artists, celebrities, society figures, drag queens, intellectuals, and other scene makers in the 1960s. From 1963 to 1968 Warhol was increasingly preoccupied with making avant-garde films that parodied the Hollywood system (a logical next step in his embrace of both mechanical reproduction and mass-media culture); many of them featured the Factory personalities he called his "superstars." In the late 1960s he managed the experimental rock band the Velvet Underground and produced their first album (and designed its cover). In 1967 he established his own print publishing business, Factory Additions, to issue editioned portfolios of screenprints reprising some of his most indelible subjects; among the first was a selection of ten soup cans. He published a novel (*a: A Novel*) in 1968, launched his own magazine, *Interview*, in 1969 (it remains in publication today), and continued to take occasional commissions for commercial work from magazines, record labels, and other companies.

On June 3, 1968, Warhol was shot through the chest by Valerie Solanas, a troubled figure marginally part of the Factory scene, and he nearly died (in fact, as earlier noted, he was clinically dead for seven minutes). Deeply shaken by this event, he shifted to a quieter lifestyle in the 1970s and focused on a relatively staid practice of portrait commissions for wealthy patrons—in pursuit of what he called "Business Art." This practice reached the brink of self-parody as it expanded to include signing on with a modeling agency and appearing in ads for Vidal Sassoon, Pioneer Electronics, and other companies, as well as performing occasional cameos on television shows, including *The Love Boat* (1985). "Being good in business is the most fascinating kind of art," proclaimed Warhol.[40] Also in the 1980s he published a memoir, *POPism: The Warhol '60s* (1980), and revitalized his painting career by collaborating with a number of emerging artists, including the Neo-Expressionist painter Jean-Michel Basquiat and the graffitist Keith Haring.

Despite Warhol's dominant presence in both the art world and the popular imagination, and although his work was the subject of several major American and European exhibitions from the 1960s through the 1980s, there were only two large Warhol exhibitions in New York, both at the Whitney Museum of American Art, before the artist died prematurely in 1987, during gallbladder surgery (a routine procedure complicated in Warhol's case by the extensive damage inflicted years earlier by Solanas's gun).[41] Although The Museum of Modern Art had been one of the first museums to acquire a Warhol painting, in 1962, when it accessioned *Gold Marilyn*, the Museum remained ambivalent about him throughout his lifetime. Two years after Warhol's death MoMA finally mounted a retrospective of his work; densely packed galleries paid tribute to the artist's compulsion for commodity-image repetition as a strategy for exposing a society structured around serial production and consumption [FIG. 29]. Even so, the Museum did not acquire most of its major Warhol paintings (including the *Soup Cans*) until the

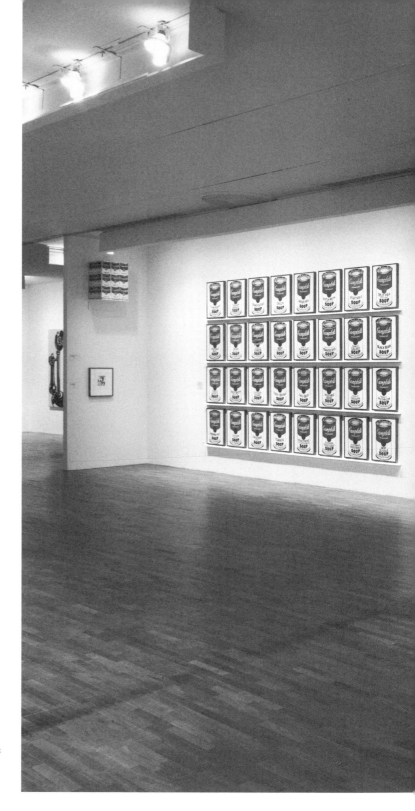

FIG. 29. Installation view of *Andy Warhol: A Retrospective*, The Museum of Modern Art, New York, February 6– May 2, 1989. From left: *Telephone* (1961); *Untitled (Unique Campbell's Soup Box)* (1964); *Cooking Pot* (1962); *Campbell's Soup Cans* (1962); *210 Coca-Cola Bottles* (1962); *200 Campbell's Soup Cans* (1962); and *Various Boxes* (1964).
THE MUSEUM OF MODERN ART ARCHIVES, NEW YORK

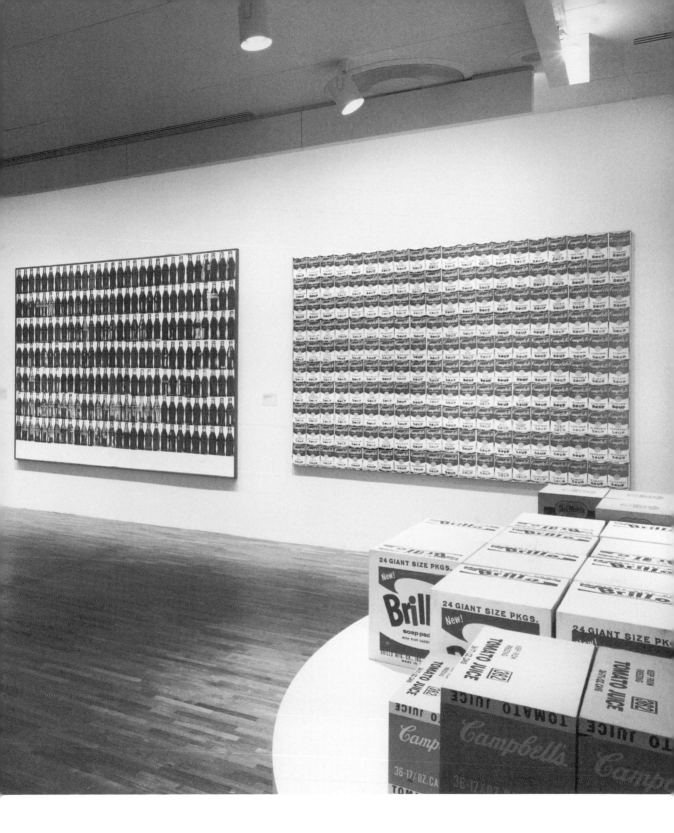

1990s and early 2000s, when Varnedoe, representing a new generation of MoMA curators, led an effort to insert the artist more prominently into the museum's narrative of modernism.[42]

Collapsing the divisions between the handmade and the mechanical, painting and photography, artworks and everyday objects, original and copy, art and commerce, and presciently exposing our unavoidable and often uneasy immersion in the world of infinitely replicating media images and sensations (an immersion that has only intensified in the present age of digital and social media), Warhol was, as the art historian Benjamin H. D. Buchloh put it, "the oracle of things to come."[43] There are few contemporary artists who have not had to reckon with him and his *Campbell's Soup Cans,* but his example has perhaps most keenly informed the generation who emerged in the 1980s and built on his legacy of appropriating imagery and objects from mass culture for use in his own art. Among the many works that are inconceivable without Warhol as a reference, two of the most trenchant are Jeff Koons's *New Shelton Wet/Dry Doubledecker* (1981; **FIG. 30**) and Robert Gober's *Cat Litter* (1989; **FIG. 31**).

In Koons's sleek homage to Warhol's conflation of commerce and high art, two ready-made vacuum cleaners rest inside a plexiglass showcase—a pristine, hermetically sealed shrine to consumerism, lit from within by fluorescent bulbs that cast an otherworldly glow. An air of irony or satire seems to hover around the piece, but (like Warhol) the artist insists his work does not involve critique. Gober's *Cat Litter* takes its cues from a different, more latent vein in Warhol's work that hints at the potential for certain familiar products to trigger suppressed emotion. The artist intends for one or more *Litter* bags (he made them in a small edition), to be placed on the floor, leaning against a wall. Almost as unexpected and provocative a subject in 1989 as Warhol's *Soup Cans* were in 1962, but more subtle and elliptical, the bags have a curious, slightly abject presence in a room or gallery. They seem at first to be readymades, but they are actually exacting plaster replicas that Gober crafted painstakingly by hand, their minute distortions making the familiar unfamiliar. Gober, a gay artist who works with memories of a 1960s suburban childhood and its sometimes repressive, puritanical attitudes, picks up the undercurrents of camp in Warhol's *Soup Cans,* the pathos of his *Marilyns,* and the uncanny in his *Brillo Boxes* to make the litter bag a carrier of disquieting domestic associations. This effect is amplified when the bags are presented together with other familiar yet strange Gober objects in a room-size installation (another now commonplace way of presenting art that Warhol helped instigate in the 1960s).

Of course, a number of artists have made works by appropriating Warhol's appropriations very specifically. The first was Sturtevant, who began making inexact but uncannily similar copies of the works of her contemporaries, starting with Warhol, in the 1960s. Constructing versions of Warhol's 1965 *Flowers*

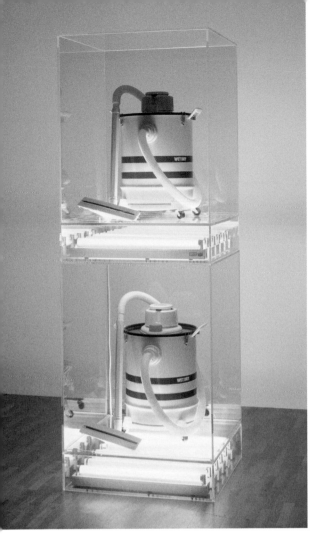

FIG. 30. Jeff Koons (American, born 1955). *New Shelton Wet/Dry Doubledecker*. 1981. Vacuum cleaners, plexiglass, and fluorescent lights, 8′ 5⅝″ × 28″ × 28″ (245.4 × 71.1 × 71.1 cm). THE MUSEUM OF MODERN ART, NEW YORK. GIFT OF WERNER AND ELAINE DANNHEISSER

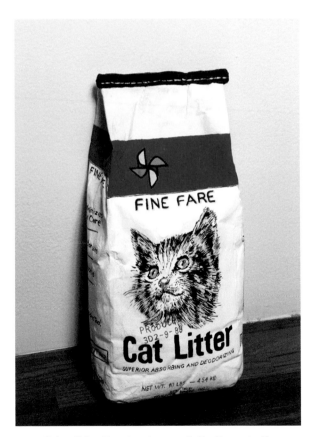

FIG. 31. Robert Gober (American, born 1954). *Cat Litter*. 1989. Plaster, ink, and latex paint, 17 × 8 × 5″ (43.2 × 20.3 × 12.7 cm). THE MUSEUM OF MODERN ART, NEW YORK. ACQUISITION FROM THE WERNER DANNHEISSER TESTAMENTARY TRUST

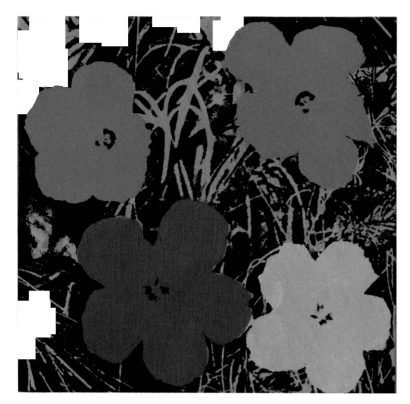

FIG. 32. Sturtevant (American, 1924–2014). *Warhol Flowers*. 1965. Synthetic polymer paint and silkscreen ink on canvas, 11¹⁄₁₆ × 11¹⁄₁₆″ (28 × 28 cm)

FIG. 33. Banksy (British, born 1974[?]). *Tesco Value Tomato Soup*. 2004. Oil on canvas, 48⁷⁄₁₆ × 36¼″ (123 × 92 cm)

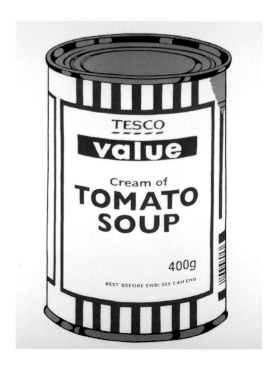

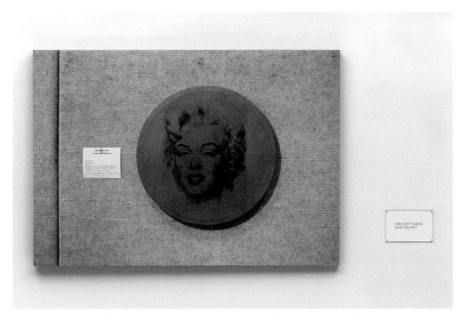

FIG. 34. Louise Lawler (American, born 1947). *Does Andy Warhol Make You Cry?*. 1988. Silver dye bleach print (Cibachrome) and Plexiglas wall label with gilded lettering, photograph: 27 9/16 × 39 3/8" (70 × 100 cm); label: 4 5/16 × 6 5/16" (10.2 × 15.1 cm). THE MUSEUM OF MODERN ART, NEW YORK. GIFT OF GABRIELLA DE FERRARI IN HONOR OF KAREN DAVIDSON

using his discarded silkscreens—which he happily shared with her—she sought to expand upon Warhol's probing of the relationship between originality and repetition [**FIG. 32**]. Others who have engaged specific works by Warhol range from the street artist Banksy, who breezily riffed on the inescapable influence of Warhol's *Campbell's Soup Cans* by translating the American brand into one that would resonate in his native Britain [**FIG. 33**], to the Conceptual photographer Louise Lawler, who meditated more deeply on the emotional and conceptual implications of Warhol's art, career, and legacy. She took a photograph of *Round Marilyn* (1962) when it came up for auction at Christie's in 1988 [**FIG. 34**]. Zeroing in on the uncomfortable, even heartbreaking, tensions between the first-blush glamour and abiding poignancy of Warhol's subject (Monroe); between the status of *Round Marilyn* as "pure" art object and luxury commodity within the then (and now) overheated market for Warhol's works; and between the flippant superficiality and ruthless incisiveness of Warhol's practice overall, she asks us, in her title, *Does Andy Warhol Make You Cry?*

NOTES

1. "Swish" was the word Warhol's friend Emile de Antonio used in surmising that Warhol's manner made some in the closeted art world of the 1950s, including Jasper Johns and Robert Rauschenberg, uncomfortable. See Steven Watson, *Factory Made: Warhol and the Sixties* (New York: Pantheon, 2003), 78–79.

2. Warhol, "Artist's Comment," in "New Talent U.S.A: Prints and Drawings," *Art in America* 50, no. 1 (1962): 42.

3. Warhol, as recounted by Ivan Karp in Patrick S. Smith, ed., *Warhol: Conversations about the Artist* (Ann Arbor, MI: UMI Research Press, 1988), 212.

4. The English art critic and curator Lawrence Alloway is credited with coining the term "Pop art" in 1958, but it wasn't in wide circulation until several years later.

5. Henry Geldzahler, interview by David Bourdon, typed notes, October 4, 1987, David Bourdon papers, Archives of American Art, Smithsonian Institution, quoted in Blake Gopnik, *Warhol* (New York: Ecco/HarperCollins, 2020), 247.

6. Walter Hopps, *The Dream Colony: A Life in Art* (New York: Bloomsbury, 2017), 120.

7. Hopps, 120.

8. Irving Blum, quoted in Gopnik, *Warhol*, 249.

9. Blum, quoted in Gopnik, 249.

10. See, e.g., Victor Bockris, *The Life and Death of Andy Warhol* (New York: Bantam, 1989), 105.

11. Warhol, as quoted by Ted Carey in Patrick S. Smith, "Art 'in Extremis': Andy Warhol and His Art" (PhD diss., Northwestern, 1982), cited in Bockris, *Life and Death of Andy Warhol*, 105.

12. Bockris, 105.

13. Warhol, quoted in G[ene] R. Swenson, "What Is Pop Art? Answers from 8 Painters, Part I," *Artnews* 62, no. 7 (November 1963): 26.

14. See Gopnik, *Warhol*, 7, 38.

15. Henry T. Hopkins, "Andy Warhol, Ferus Gallery," *Artforum* 1, no. 4 (September 1962): 15. Reprinted in Steven Henry Madoff, *Pop Art: A Critical History* (Berkeley: University of California Press, 1997), 266.

16. William D. Tyler, "Here Are the '60s All-Star Ads," *Advertising Age* 32, no. 11 (March 13, 1961): 78, cited in Kirk Varnedoe and Adam Gopnik, *High & Low: Modern Art and Popular Culture* (New York: The Museum of Modern Art, 1990), 426n210.

17. Hopps, *Dream Colony*, 122.

18. Hopkins, "Andy Warhol," 15.

19. Matt Weinstock, "Insects Bug You? Here's the Reason," *Los Angeles Times*, July 19, 1962. The cans were placed in the window of the Primus-Stuart Galleries.

20. Carol Vogel, "Modern Acquires 2 Icons of Pop Art," *New York Times*, October 10, 1996.

21. Kirk Varnedoe, "New Acquisitions," *MoMA Magazine* 24 (Winter/Spring 1997): 26.

22. Andy Warhol and Pat Hackett, *POPism: The Warhol '60s* (New York: Harcourt Brace Jovanovich, 1980), 22.

23. Warhol and Hackett, *POPism*, 22.

24. Warhol and Hackett, 22.

25. Warhol, quoted in Hopps, *Dream Colony*, 122.

26. Warhol, quoted in Douglas Arango, "Underground Films: Art or Naughty Movies," *Movie TV Secrets* (June 1967), n.p., cited in Benjamin H. D. Buchloh, "Andy Warhol's One-Dimensional Art: 1956–1966," in Kynaston McShine, *Andy Warhol: A Retrospective* (New York: The Museum of Modern Art, 1989), 40.

27. Warhol, quoted in Swenson, "What Is Pop Art?," 26.

28. Although Eleanor Ward, owner of the Stable Gallery, and the gallery's director, Alan Groh, did not identify any *Soup Can* works among those they recollected as having been in the show when they provided a list to be published in the Warhol catalogue raisonné, a "large Campbell's Soup Cans" painting was listed by Warhol in *POPism* (p. 25) as one of the works in the exhibition.

29. John Coplans, "The New Paintings of Common Objects," *Artforum* 1, no. 6 (November 1962): 28.

30. Stanley Kunitz, quoted in "A Symposium on Pop Art," *Arts Magazine* 37, no. 7 (April 1963): 41. Reprinted in Madoff, *Pop Art*, 75. Kunitz was likely referring to canvases like *200 Campbell's Soup Cans* (see fig. 14), which involved the use of a stencil, rather than the slightly earlier series of thirty-two *Campbell's Soup Cans*, which did not.

31. Warhol's *Brillo Boxes* look identical to actual Brillo boxes found in the supermarket, but as they were handmade, not ready-made, they propose a different challenge to the definition of art than that levied by Duchamp. For more on the philosophical implications of Warhol's *Brillo Boxes*, see Arthur C. Danto, *The Transfiguration of the Commonplace* (Cambridge, MA: Harvard University Press, 1983).

32. Marcel Duchamp, quoted in Rosalind Constable, "New York's Avant-Garde, and How It Got There," in "The Avant-Garde," special issue, *Sunday Herald Tribune Magazine*, May 17, 1964, 10.

33. William L. O'Neill, *Coming Apart: An Informal History of America in the 1960s* (New York: Quadrangle, 1977), 3, quoted in Irving Sandler, *American Art of the 1960s* (New York: Harper & Row, 1988), 81.

34. Sidra Stich, *Made in USA: An Americanization in Modern Art, the '50s and '60s* (Berkeley: University of California Press, 1987), 89.

35. Andy Warhol, *The Philosophy of Andy Warhol (From A to B and Back Again)* (New York: Harcourt Brace Jovanovich, 1975), 100–1.

36. Warhol and Hackett, *POPism*, 50.

37. Warhol, quoted in Gretchen Berg, "Andy: My True Story," *Los Angeles Free Press*, March 17, 1967, 3.

38. Henry Geldzahler, quoted in Isabel Eberstadt, "Are You Human, Andy" (typescript, c. 1965), Fernanda Eberstadt personal papers, quoted in Gopnik, *Warhol*, 36.

39. Edward Ruscha, quoted in McShine, *Andy Warhol*, 429.

40. Warhol, *Philosophy of Andy Warhol*, 92.

41. The two exhibitions at the Whitney Museum were a midcareer survey in 1971 and a show titled *Andy Warhol: Portraits of the 70s* in 1979.

42. Although MoMA acquired relatively few Warhol paintings from the 1960s through the 1980s, the Museum did acquire several of Warhol's most significant print projects during those decades, thanks in many cases to donations from Philip Johnson, the architect and long-standing MoMA trustee, or his partner, David Whitney. It was also Johnson who donated *Gold Marilyn Monroe* in 1962 and several other major Warhol paintings in the 1990s.

43. Benjamin H. D. Buchloh, "Roundtable: The Predicament of Contemporary Art," in Hal Foster et al., *Art Since 1900: Modernism, Antimodernism, Postmodernism,* vol. 2. (New York: Thames & Hudson, 2004), 776.

FOR FURTHER READING

Bockris, Victor. *The Life and Death of Andy Warhol*. New York: Bantam, 1989.

De Salvo, Donna M. *Andy Warhol: From A to B and Back Again*. Exh. cat. New York: Whitney Museum of American Art, 2018.

Gopnik, Blake. *Warhol*. New York: Ecco/HarperCollins, 2020.

Livingstone, Marco. *Pop Art: A Continuing History*. New York: Thames & Hudson, 2000.

McShine, Kynaston. *Andy Warhol: A Retrospective*. Exh. cat. New York: The Museum of Modern Art, 1989.

Watson, Steven. *Factory Made: Warhol and the Sixties*. New York: Pantheon, 2003.

BY ANDY WARHOL

Warhol, Andy. *The Andy Warhol Diaries*. Edited by Pat Hackett. New York: Warner Books, 1989.

Warhol, Andy. *The Philosophy of Andy Warhol (From A to B and Back Again)*. New York: Harcourt Brace Jovanovich, 1975.

Warhol, Andy, and Pat Hackett, *POPism: The Warhol '60s*. New York: Harcourt Brace Jovanovich, 1980.

Leadership support for this publication is provided by the Kate W. Cassidy Foundation.

Additional funding is provided by the Dale S. and Norman Mills Leff Publication Fund.

Produced by the Department of Publications,
The Museum of Modern Art, New York

Leadership support for this publication is provided by
the Kate W. Cassidy Foundation.

Additional funding is provided by the Dale S. and
Norman Mills Leff Publication Fund.

Hannah Kim, Business and Marketing Director
Don McMahon, Editorial Director
Marc Sapir, Production Director
Curtis R. Scott, Associate Publisher

Edited by Don McMahon
Designed by Miko McGinty and Rita Jules
Layout by Amanda Washburn
Production by Matthew Pimm
Proofread by Rebecca Roberts
Printed and bound by Ofset Yapımevi, Istanbul

Typeset in Ideal Sans
Printed on 150 gsm Arctic Silk Plus

Published by The Museum of Modern Art
11 West 53 Street
New York, NY 10019-5497
www.moma.org

ISBN: 978-1-63345-136-0

Distributed in the United States and Canada by
ARTBOOK | D.A.P.
75 Broad Street
Suite 630
New York, NY 10004
www.artbook.com

Distributed outside the United States and Canada by
Thames & Hudson
181A High Holborn
London WC1V 7QX
www.thamesandhudson.com

Printed and bound in Turkey